Dogphabet

Dogphabet

A whimsical celebration
of our favourite canine
companions

Illustrations by
Meredith Jensen

Harper *by* Design

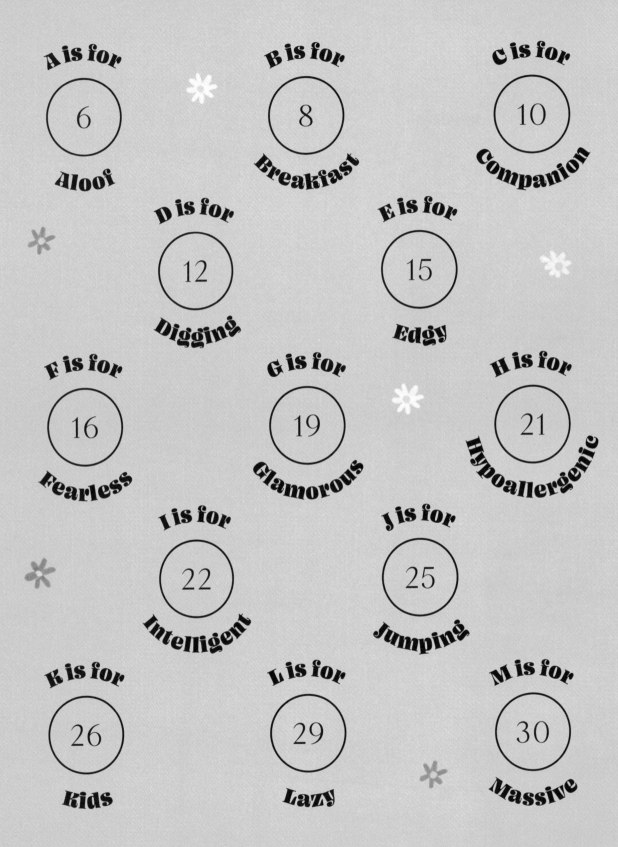

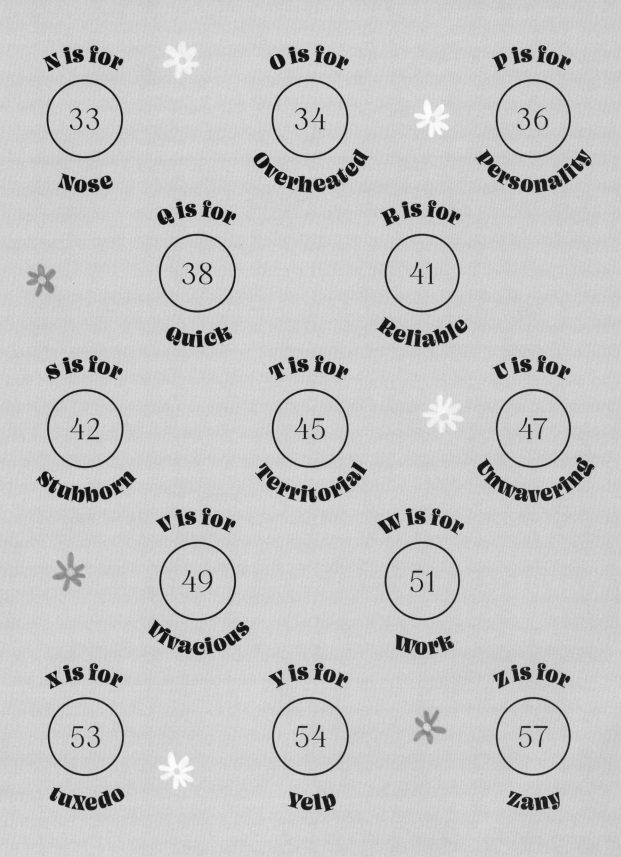

N is for
33
Nose

O is for
34
Overheated

P is for
36
Personality

Q is for
38
Quick

R is for
41
Reliable

S is for
42
Stubborn

T is for
45
Territorial

U is for
47
Unwavering

V is for
49
Vivacious

W is for
51
Work

X is for
53
Tuxedo

Y is for
54
Yelp

Z is for
57
Zany

A is for
Aloof

Dalmatian

One of the most recognisable dog breeds on the planet, Dalmatians are active dogs with an endless capacity for exercise. Smart and sensitive, they apparently never forget mistreatment so don't respond well to harsh training.

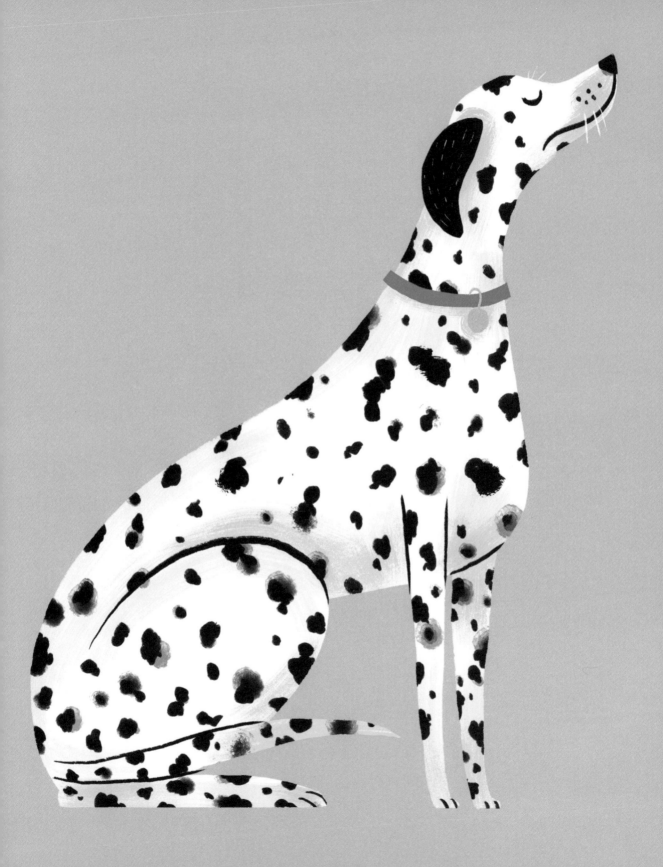

B is for
Breakfast

Welsh Corgi

A lifetime favourite of Britain's Queen Elizabeth II, these little dogs are happy, loving and intelligent but can be stubborn at times. They are prone to overeating and obesity, so be sure to monitor their food intake and never leave the fridge door open.

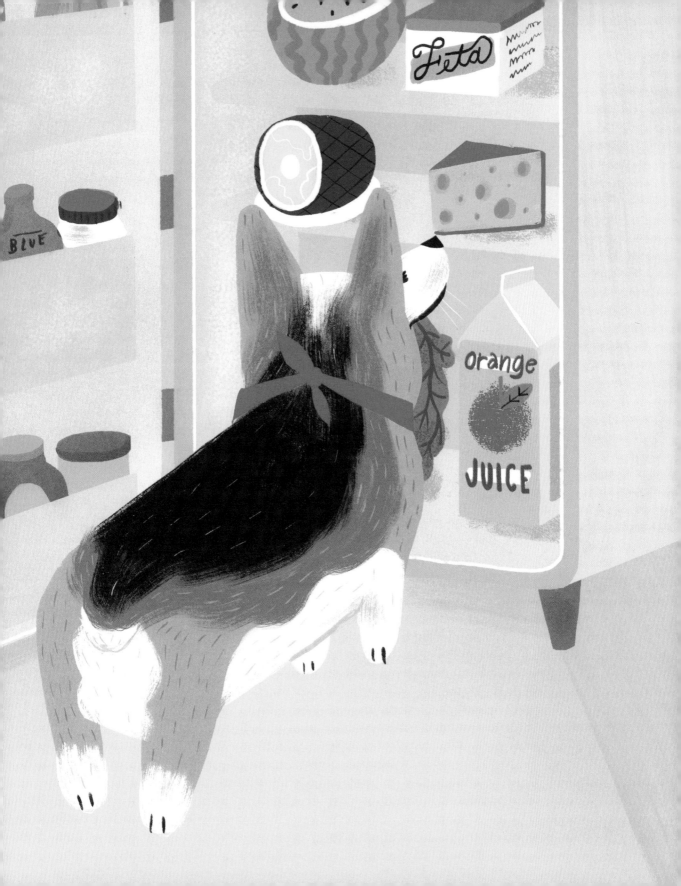

C is for
Companion

Labrador Retriever

Say hello to your new best friend!
Labs — as they are commonly
referred to — are one of the world's
most popular dog breeds and
for good reason too. They are
outgoing, sweet-natured and easy
to please, making them great
assistance dogs. They're also useful
in search and rescue but not very
good at being guard dogs!

D is for Digging

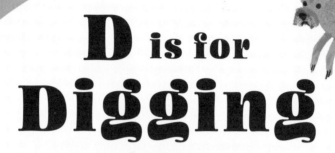

Border Terrier

Alert and good natured, Border Terriers were originally bred to drive foxes out of hiding places during hunting season. This means that given a lack of supervision and enough time alone, they'll dig under, climb over or even through a fence in order to explore.

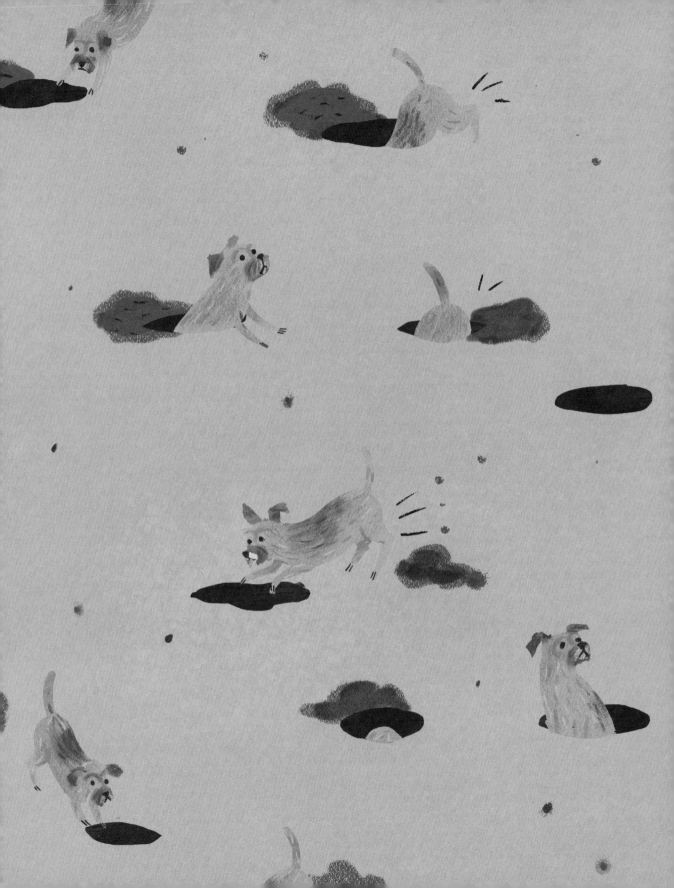

E is for
Edgy

Boxer

Playful, loving and loyal, boxers are alert guard dogs that like to protect their families and homes. They have been used by the military and police in search-and-rescue operations and in helping to apprehend suspects.

F is for Fearless

Dachshund

Dachshunds might only be half a dog high, but they were bred in Germany to hunt badgers and they are always ready to take on creatures much larger than themselves. Courageous, bold and occasionally snappy, these sausage dogs are definitely more bark than bite.

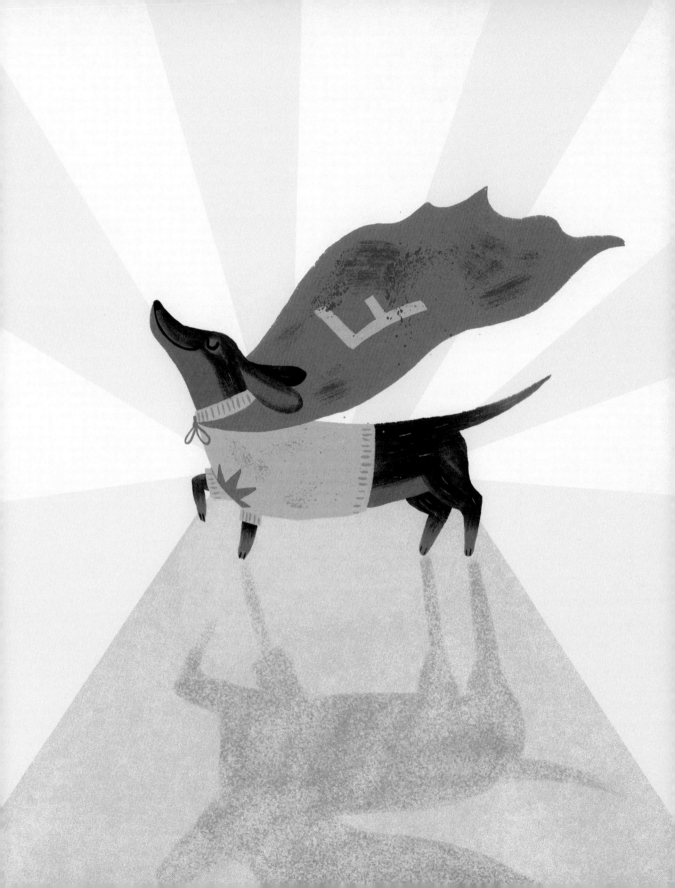

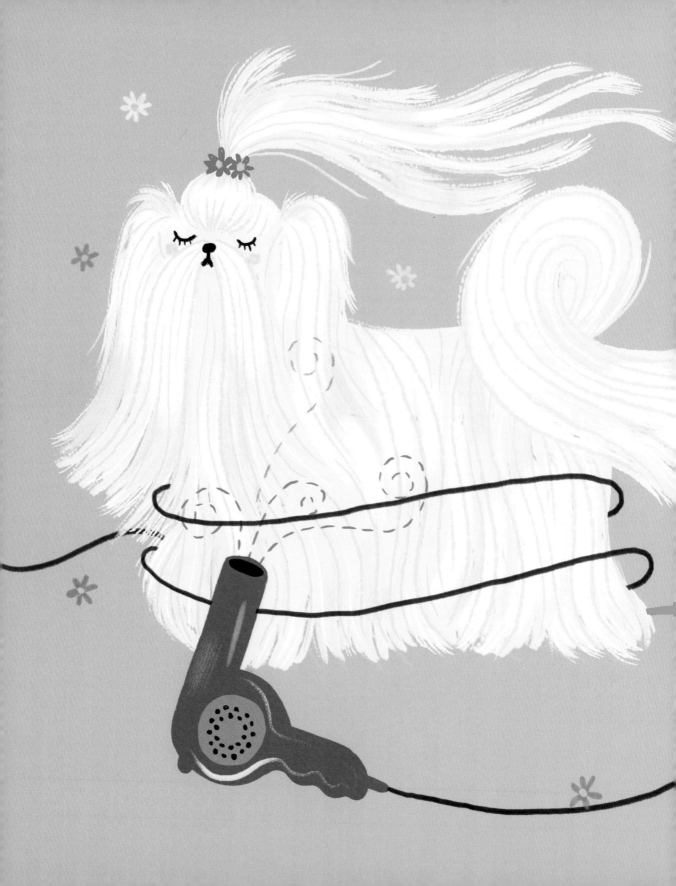

G is for
Glamorous

Maltese

Delicate and aristocratic, these
elegant toy dogs are famed for the
thick silky coat that falls all the
way to the ground. In full flight it's
almost like they are floating above
a majestic cloud. In ancient times
Maltese came in many colours, but
these days they are always white.

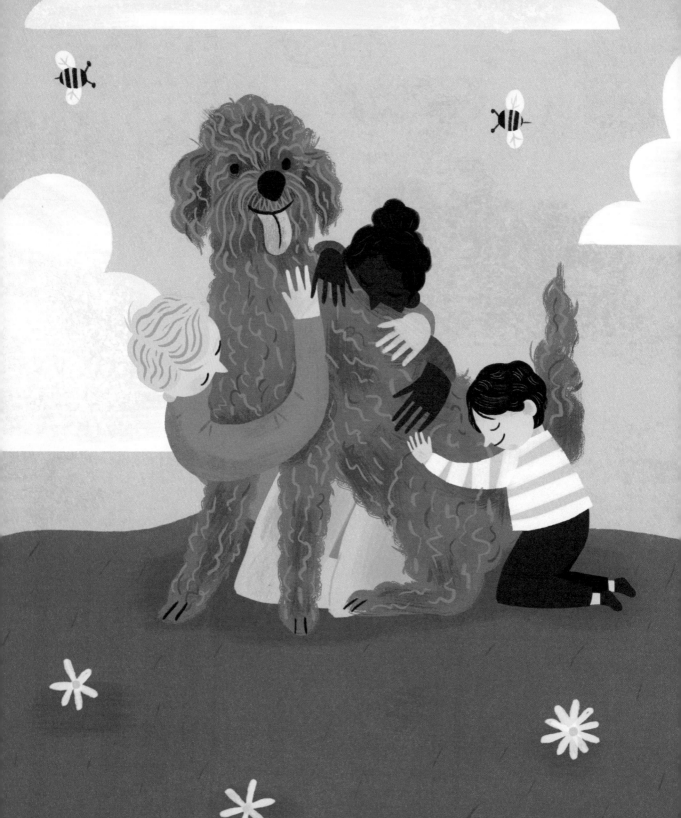

H is for
Hypoallergenic

Labradoodle

A great option for allergy sufferers, this crossbreed is used around the world as hypoallergenic assistance and therapy dogs. Smart, sociable and super-friendly, they make a lovable addition to any family.

I is for
Intelligent

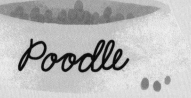

Poodle

One of the most intelligent dog breeds, poodles are elegant, proud and playful. They are always up for a game, hate being left alone and come in three convenient sizes: toy, miniature and standard.

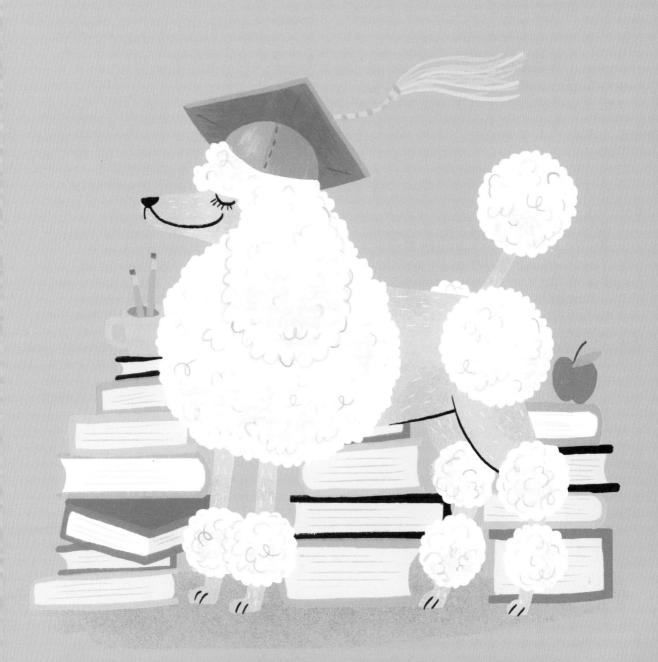

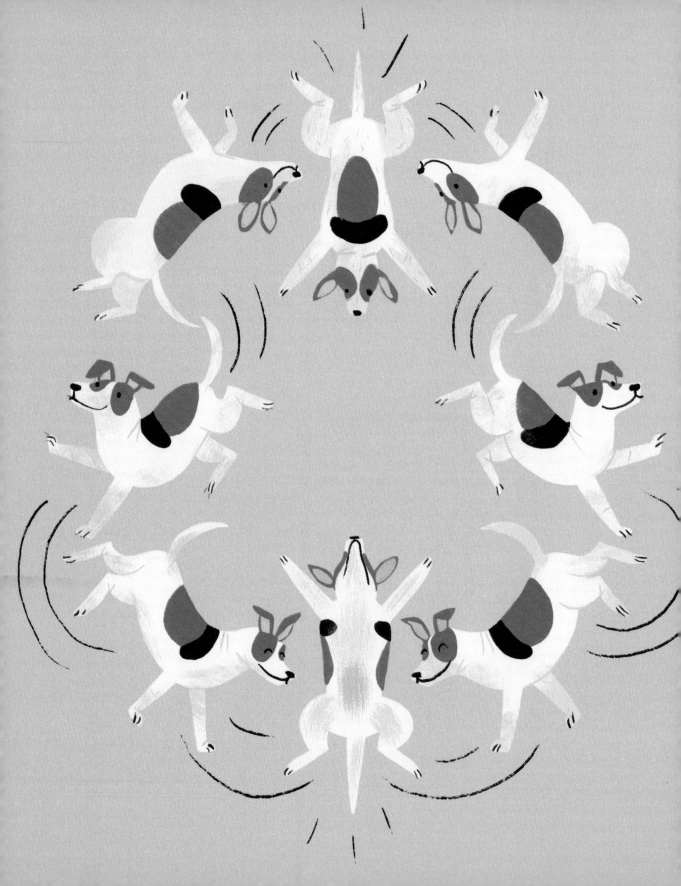

J is for
Jumping

Jack Russell Terrier

It's a fact: Jack Russells are bouncy dogs full of boundless energy, who like to jump up on people. They are capable of leaping more than one and a half metres high, which is no mean feat for a small dog. Only experienced dog owners need apply!

K is for Kids

Cavalier King Charles Spaniel

While these little spaniels have an aristocratic past, they are anything but snobs. They get along exceptionally well with children, other dogs and strangers, and are very willing to be trained, making them perfect for first-time dog owners.

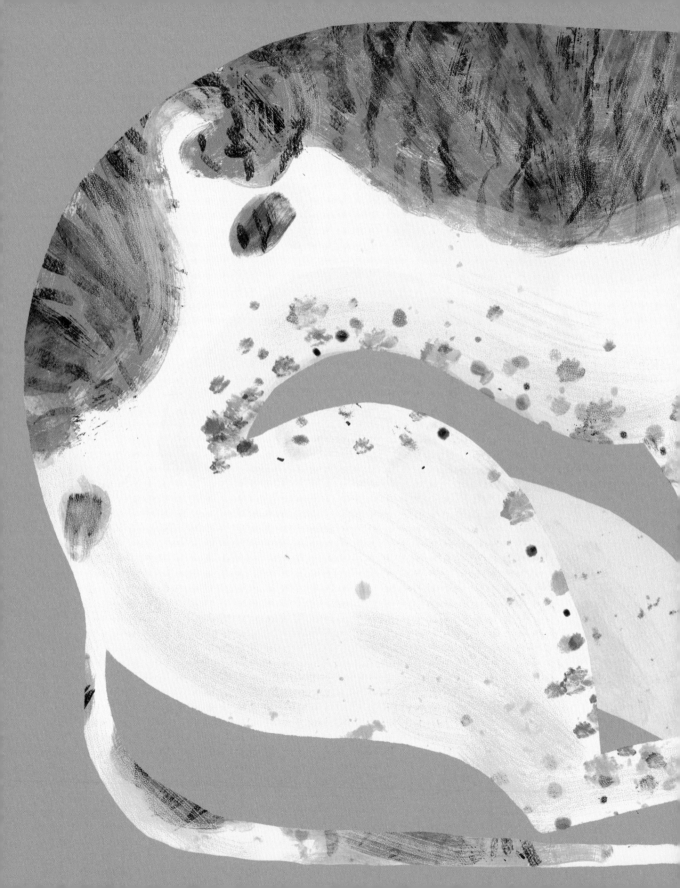

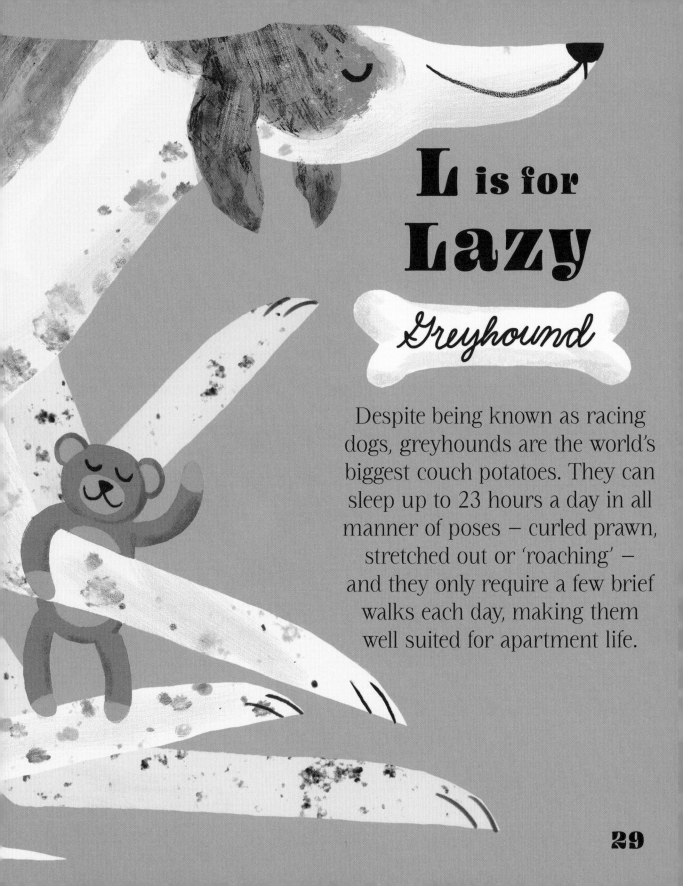

L is for Lazy

Greyhound

Despite being known as racing dogs, greyhounds are the world's biggest couch potatoes. They can sleep up to 23 hours a day in all manner of poses – curled prawn, stretched out or 'roaching' – and they only require a few brief walks each day, making them well suited for apartment life.

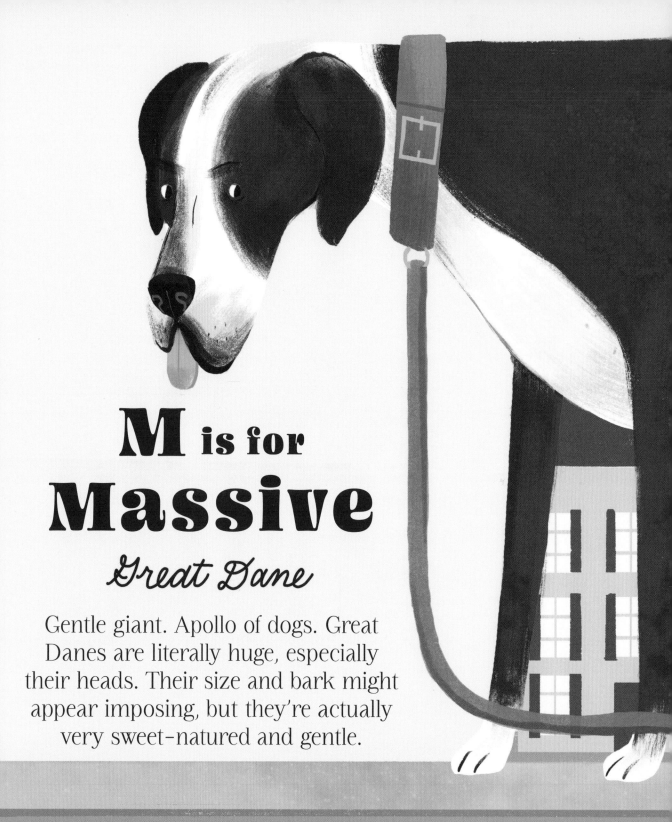

M is for
Massive
Great Dane

Gentle giant. Apollo of dogs. Great Danes are literally huge, especially their heads. Their size and bark might appear imposing, but they're actually very sweet-natured and gentle.

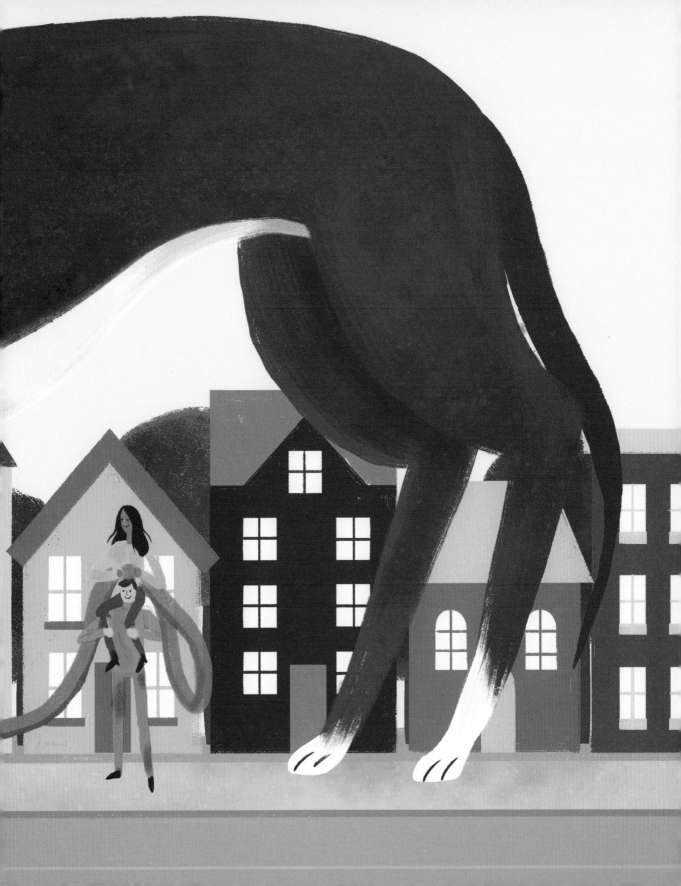

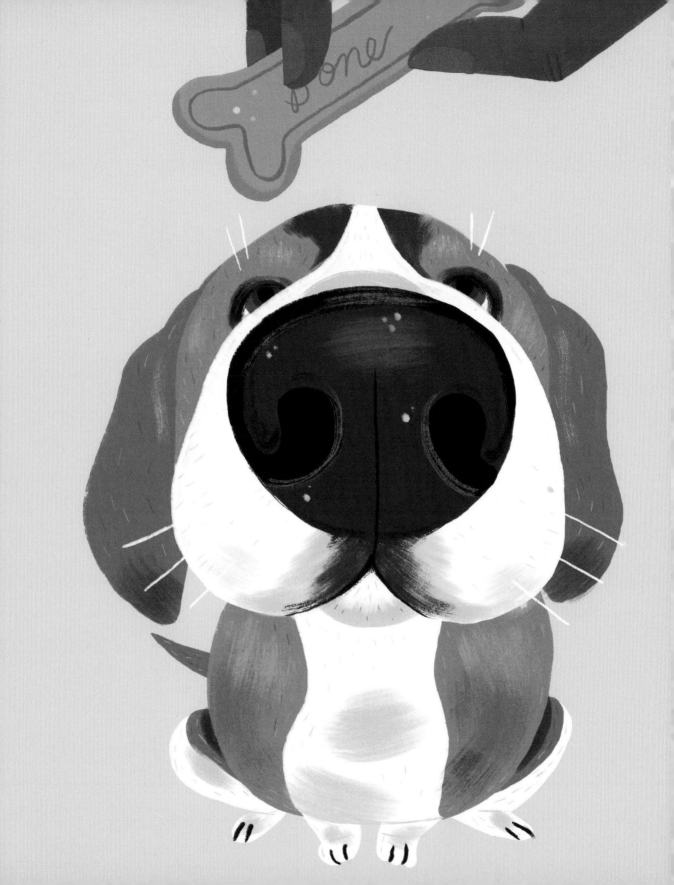

N is for Nose

Beagle

There's a very simple reason why beagles work at airports and seaports all around the world: as a scent hound, their nose is the most important part of their anatomy and controls their brain. If these gentle, intelligent dogs smell something interesting, nothing else exists!

O is for
Overheated

British Bulldog

Originally bred as aggressive fighting dogs, bulldogs were rehabilitated in the 1800s to be gentle and affectionate. They possess a unique body and head shape that makes them cumbersome to carry and intolerant to heat and humidity, and would much prefer to be indoors and shaded while everyone else is outside.

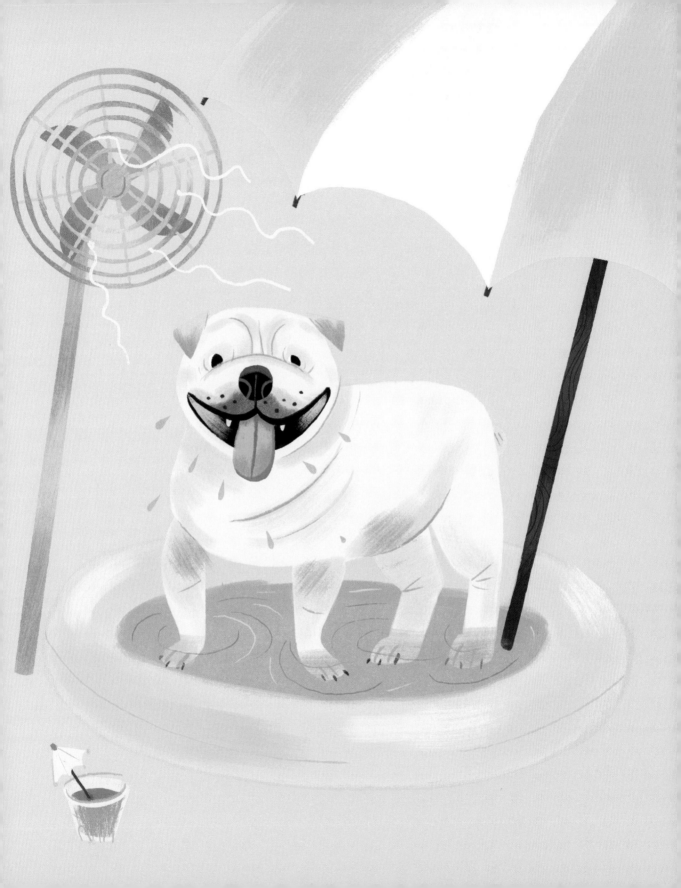

P is for
Personality

Chihuahua

Chihuahuas are the world's smallest dogs with the world's biggest personalities. Curious and bold, and demanding if overindulged, they will run your life if allowed, so be ready with plenty of training and rewards to show them who's queen bee.

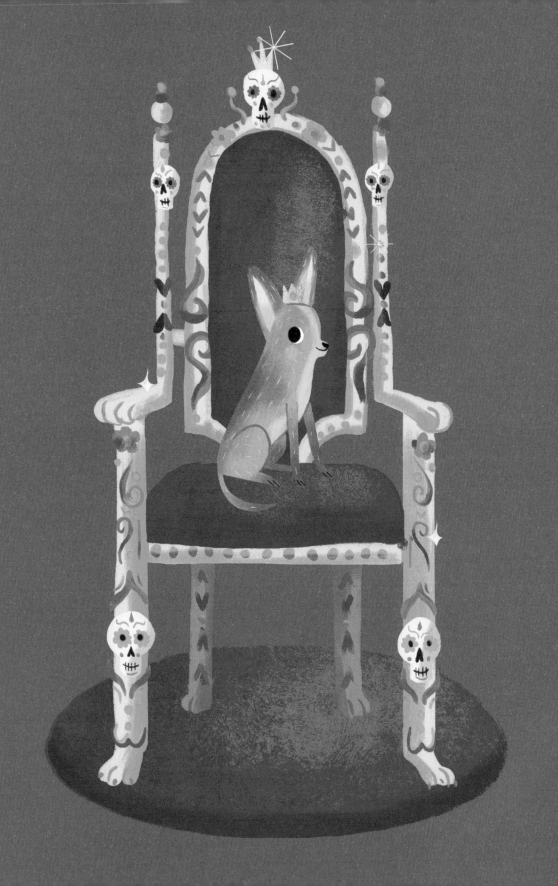

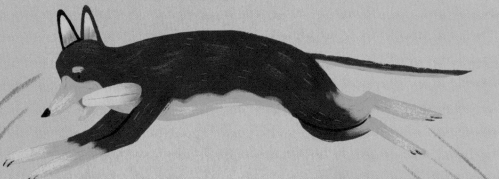

Q is for
Quick

Kelpie

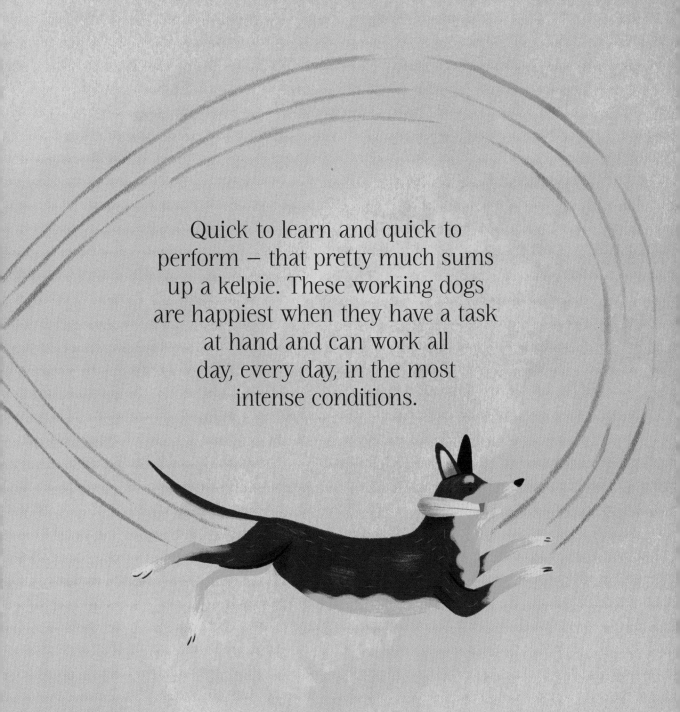

Quick to learn and quick to
perform – that pretty much sums
up a kelpie. These working dogs
are happiest when they have a task
at hand and can work all
day, every day, in the most
intense conditions.

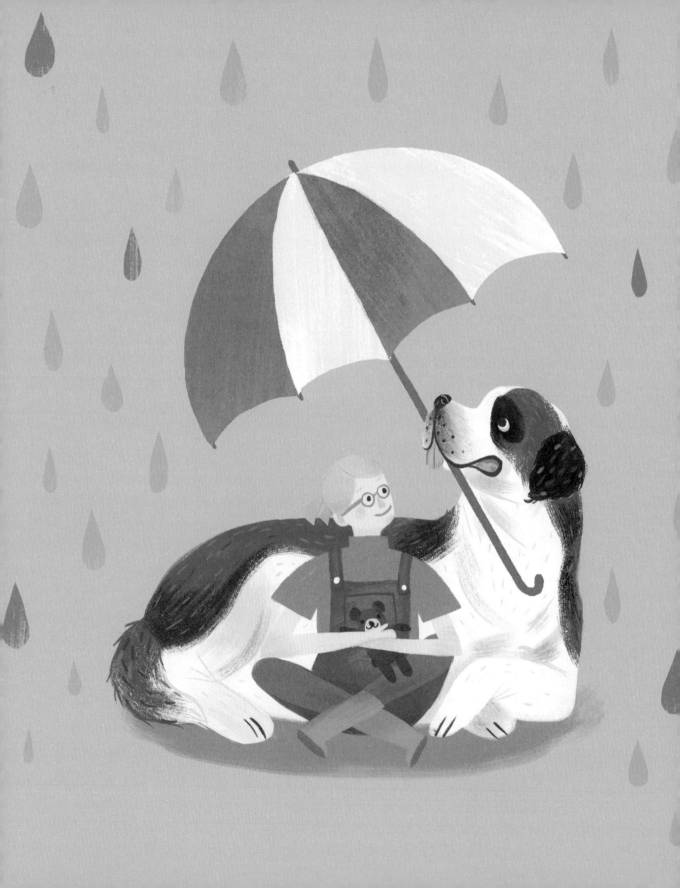

R is for
Reliable

Saint Bernard

Originally bred for search-and-rescue operations in the Italian-Swiss Alps, these gentle giants are friendly, helpful and patient. They have a steady, benevolent temperament and are kind and careful with children.

S is for
Stubborn

French Bulldog

Warning: Frenchies are free thinkers. Equal parts frustrating and delightful, their stubborn nature can make them difficult to budge (both physically and mentally) if they decide to dig their heels in.

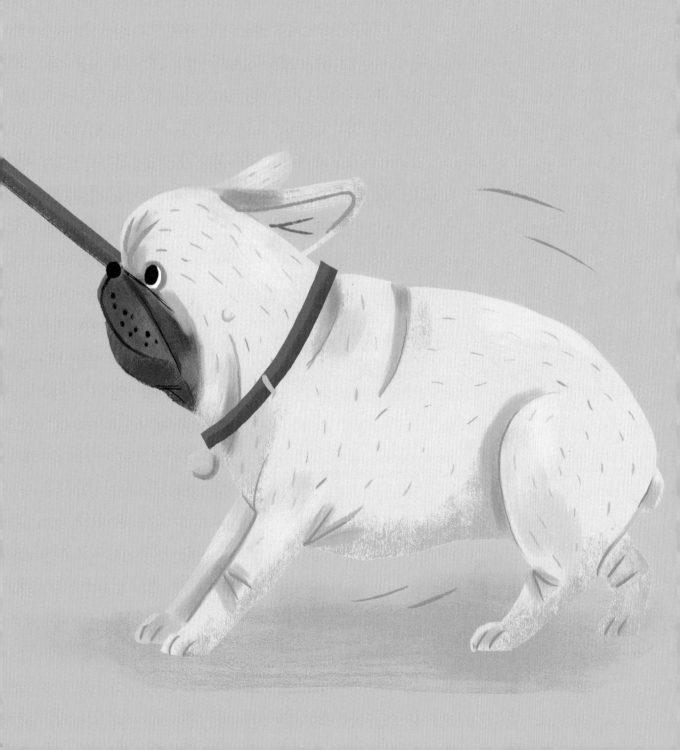

T is for
Territorial

Schnauzer

While schnauzers don't generally bark without good reason, they will if they sense anything is threatening the homes and families they protect. Hardworking and loyal, they can be highly suspicious of strangers until their owners instruct them otherwise.

U is for
Unwavering

Staffordshire Bull Terrier

It's a well-known fact that Staffies are sweet and loyal to their owners. Their greatest desire is to spend time with people, and this loving and trusting nature extends to the children in their lives too.

V is for
vivacious

Bichon Frise

Resembling a fluffy child's toy, bichon frises are the cheerleaders of the dog world. With a baby-doll face and a winning can-do personality, they like to be the centre of attention and charm everyone they meet.

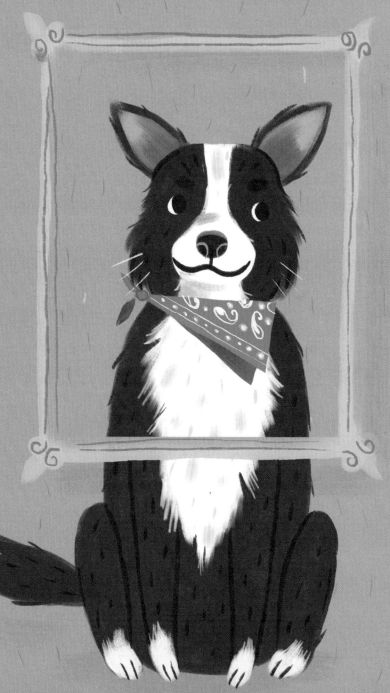

Employee of
The Month

W is for Work

Border Collie

Border collies are the ideal employee. Not bred to lie around quietly and be cuddled, they are quick learners, hardworking and like to be challenged often. Give that dog a raise, and a bone!

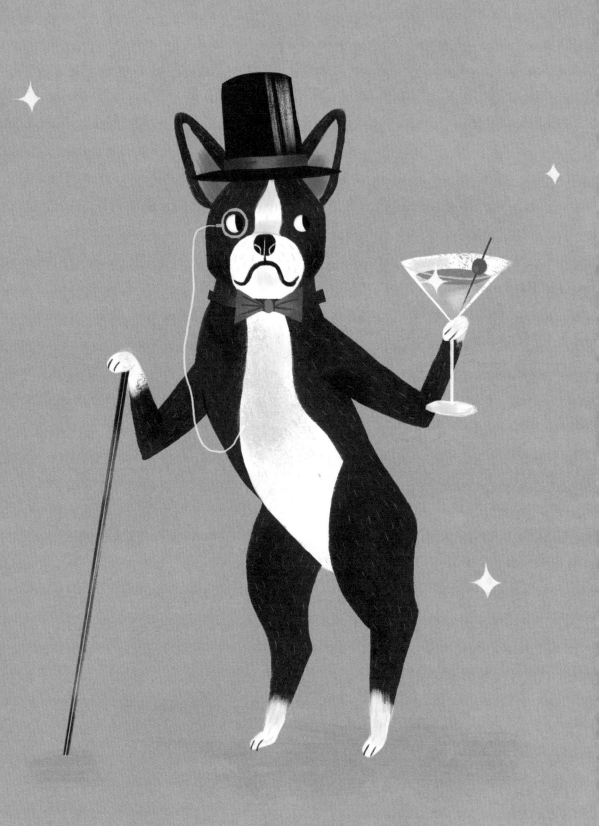

X is for tuxedo

Boston Terrier

Have you ever noticed that the trademark coat patterns on a Boston terrier resemble a tuxedo? It's for this essential sartorial feature that these friendly dogs were nicknamed the 'American Gentleman'.

Y is for
Yelp

Pomeranian

If you live in close proximity to your neighbours, then this might not be the dog for you. Poms are feisty, curious little dogs who like to bark A LOT and are sometimes unsure when (or how) to stop.

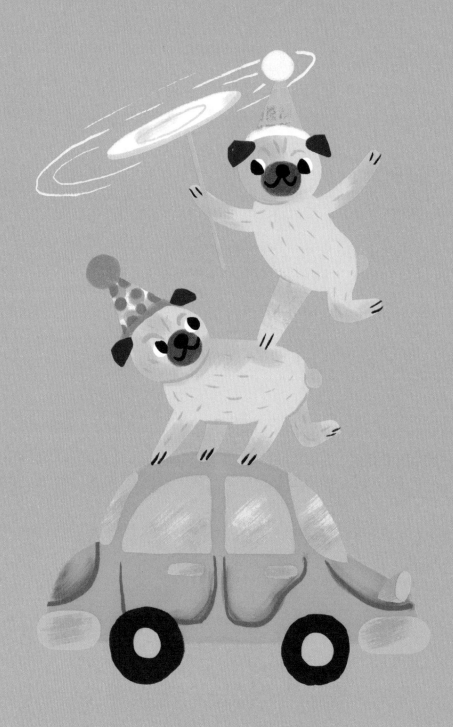

Z is for Zany

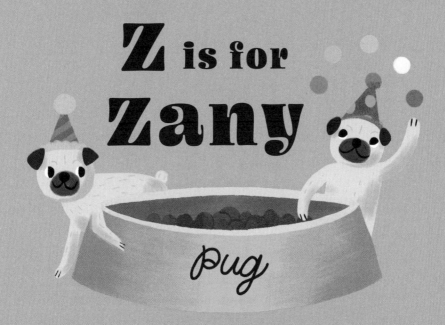

Pug

Pugs are often described as 'a lot of dog in a small space'. They are friendly, comical dogs with big personalities who thrive on human interaction and are always happy to play the clown.

Puppy School

Beagle

Life span: 10 to 15 years

Likes: barking, howling, kids, other dogs, strangers

Dislikes: boredom, being alone, being interrupted when eating, cold weather

Bichon Frise

Life span: 14 to 15 years

Likes: apartment life, new owners, kids, strangers, other dogs

Dislikes: being alone

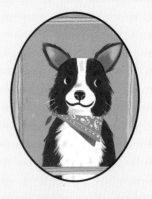

Border Collie

Life span: 12 to 15 years

Likes: extreme temperatures, kids, strangers, exercise, stimulation, herding

Dislikes: apartment life, new owners, being alone

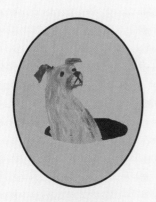

Border Terrier

Life span: 12 to 15 years

Likes: digging, chasing, hunting, chewing, barking, apartment life

Dislikes: being alone, unknown cats and dogs, small wildlife

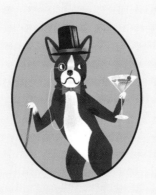

Boston Terrier

Life span: 11 to 13 years

Likes: apartment life, strangers, kids, other dogs, older people, eating

Dislikes: extreme temperatures, being outside

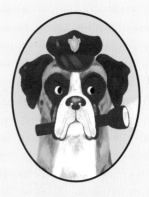

Boxer

Life span: 10 to 12 years

Likes: exercise, apartment life, physical contact, snoring, drooling

Dislikes: being alone, extreme temperatures

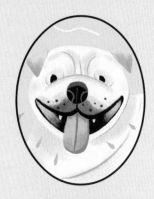

British Bulldog

Life span: 8 to 10 years

Likes: kids, strangers, barking, snoring, farting, eating, apartment life

Dislikes: extreme temperatures, other dogs, living outside

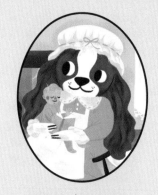

Cavalier King Charles Spaniel

Life span: 12 to 15 years

Likes: other dogs, kids, strangers, eating, apartment life, shadowing their owner

Dislikes: being alone, hot weather, living outdoors

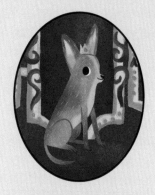

Chihuahua

Life span: 15 to 17 years

Likes: apartment life, kids, being a guard dog, being carried around

Dislikes: boredom, being alone, extreme temperatures, other dogs, strangers, being scolded, living outside

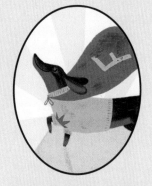

Dachshund

Life span: 12 to 16 years

Likes: barking, eating, toys, attention, socialising, apartment life

Dislikes: strangers, cold weather, jumping up or down from heights

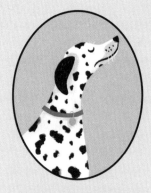

Dalmatian

Life span: 11 to 13 years

Likes: games, exercise, kids, other dogs

Dislikes: being scolded, apartment life

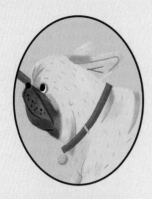

French Bulldog

Life span: 11 to 13 years

Likes: kids, strangers, other dogs, apartment life, new owners

Dislikes: being alone, extreme temperatures

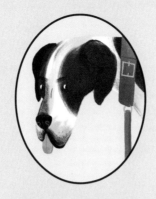

Great Dane

Life span: 8 to 10 years

Likes: other dogs, kids, strangers, drooling

Dislikes: apartment life, being alone, cold weather, new owners

Greyhound

Life span: 10 to 13 years

Likes: other dogs, chasing small animals, apartment life, sleeping

Dislikes: extreme temperatures, sitting, being scolded

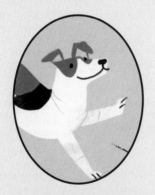

Jack Russell Terrier

Life span: 12 to 14 years

Likes: other dogs, kids, strangers, barking, chewing, digging, hunting, exercise, activities

Dislikes: being bored

Kelpie

Life span: 10 to 13 years

Likes: exercise, hot weather, barking, hunting

Dislikes: kids, strangers, boredom, being alone, apartment life, new owners

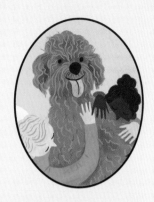

Labradoodle

Life span: 12 to 14 years

Likes: kids, strangers, other dogs, being alone, swimming

Dislikes: apartment life

Labrador Retriever

Life span: 10 to 12 years

Likes: kids, other dogs, eating, chewing, exercise

Dislikes: apartment life, being alone

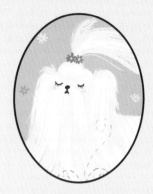

Maltese

Life span: 12 to 15 years

Likes: apartment life, barking, grooming

Dislikes: being alone, cold weather, small dogs, kids

Pomeranian

Life span: 14 to 16 years

Likes: barking, apartment life, cold weather, new owners, eating, exercise

Dislikes: other dogs, kids, strangers, hot weather

Poodle

Life span: 12 to 15 years

Likes: apartment life, kids, other dogs

Dislikes: being alone

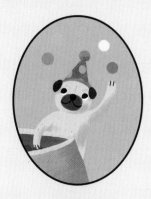

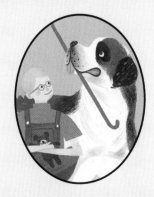

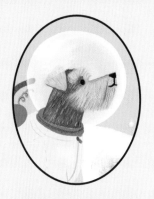

Pug

Life span: 13 to 15 years

Likes: apartment life, kids, other dogs, strangers, eating

Dislikes: extreme temperatures, being alone, being outdoors

Saint Bernard

Life span: 8 to 10 years

Likes: cold weather, company, other dogs, strangers, drooling, eating

Dislikes: being alone, hot weather, new owners, exercise

Schnauzer

Life span: 13 to 16 years

Likes: kids, apartment life, extreme temperatures, hunting, barking

Dislikes: strangers, being alone, new owners

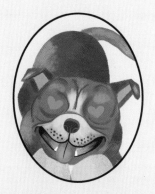

Staffordshire Bull Terrier

Life span: 12 to 14 years

Likes: kids, strangers, chewing

Dislikes: new owners, hot weather, being alone, boredom, other dogs, small animals

Welsh Corgi

Life span: 12 to 13 years

Likes: barking, biting ankles, eating, being independent, apartment life, kids

Dislikes: jumping up or down from heights

Harper *by* Design
An imprint of HarperCollins*Publishers*

HarperCollins*Publishers*
Australia • Brazil • Canada • France • Germany • Holland • Hungary
India • Italy • Japan • Mexico • New Zealand • Poland • Spain • Sweden
Switzerland • United Kingdom • United States of America

First published in Australia in 2022
by HarperCollins*Publishers* Australia Pty Limited
Level 13, 201 Elizabeth Street, Sydney NSW 2000
ABN 36 009 913 517
harpercollins.com.au

A catalogue record for this book is available from the National Library of Australia

ISBN 978 1 4607 6233 2

Publisher: Mark Campbell
Publishing Director: Brigitta Doyle
Editor: Madeleine James
Designer: Mietta Yans, HarperCollins Design Studio
Illustrator: Meredith Jensen
Printed and bound in China by RR Donnelley

8 7 6 5 4 3 2 23 24 25